ARTIST'S
LIBRARY
SERIES

W9-BOB-206

Cartooning

By Hal Tollison

Walter Foster Publishing, Inc.
3 Wrigley, Suite A
Irvine, CA 92618
www.walterfoster.com

Printed in China.
1 3 5 7 9 10 8 6 4 2
18288

TABLE OF CONTENTS

ORIGIN OF CARTOONING

As far back as the stone ages, humans have used cartoons as a form of art. It developed from scratchings on cave walls of cartoon-like representations of animals and events important to their lives.

For centuries, the totem poles of the northwest United States have exhibited comical and exaggerated faces depicting the lore of the indigenous indians. Likewise, the artists of the plains indians of the mid- and southwest United States recorded important events of their tribal lives in the forms of stick figures of people and animals on skins and on their tepees.

During the Renaissance, the time of artistic giants such as Michelangelo and Leonardo da Vinci, the cartoon came into play as a large drawing, usually done on paper and used as a model for a large oil painting, a fresco, a tapestry, and often, even for a sculpture. These cartoons were used in much the same way present artists draw their composition and construction of their painting on paper, then once it is to their liking, transfer it to canvas.

The cartoon has always been a drawing made of simplified, basic lines, and was used to convey a thought quickly perceived or to transfer a design in simplified form for further embellishment through one of the various other art forms.

INTRODUCTION

This book was designed with **you** in mind. It includes a list of suggested pens and brushes for use in practice. It also gives you practice exercises that will take you step-by-step through a process that makes each cartoon study session easier and more enjoyable than the one before!

MATERIALS

Following is an ideal list of the materials you will need for cartooning. If you are not ready to invest a lot of money, we have also included a list of just the basic materials.

Ideal List

Drawing Board (24" x 30")
Bond Paper
Pens (#170, #303, #290)
Mechanical Pens or Pen Sticks
Art Gum
Drafting Tape
Xacto Knife and Blades
Drawing Pencils (HB, 5B or 6B)
Pencil Sharpener
Metal Straight-Edge
Draftsman's Brush
Paper Clips
Hair Dryer
Reducing Glass
Small Natural Sponge

Black India Ink
Pen Holder
Pen Nibs (Various Sizes)
Kneaded Eraser
Sable Brushes (#2 and #4)
Paper Cutter (or Scissors)
Razor Blades
Non-Photo Blue Pencils
Ruler
Film Shading
Wipe Cloth
Stapler
Magnifying Glass
Masking Fluid
Blotters
T-Square

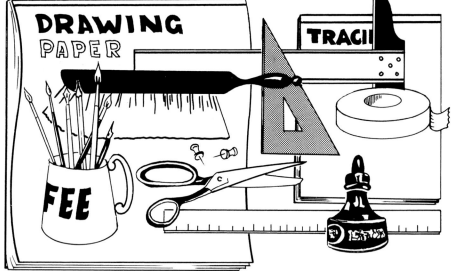

Basic List

Drawing Board (24" x 30")
Bond Paper
Sable Brush (#2)
Scissors
#2 Pencil
T-Square

Black India Ink
Kneaded Rubber Eraser
Staff Pen and Nibs
Razor Blades
Wipe Cloth
Drafting Tape

STUDIO SETUP

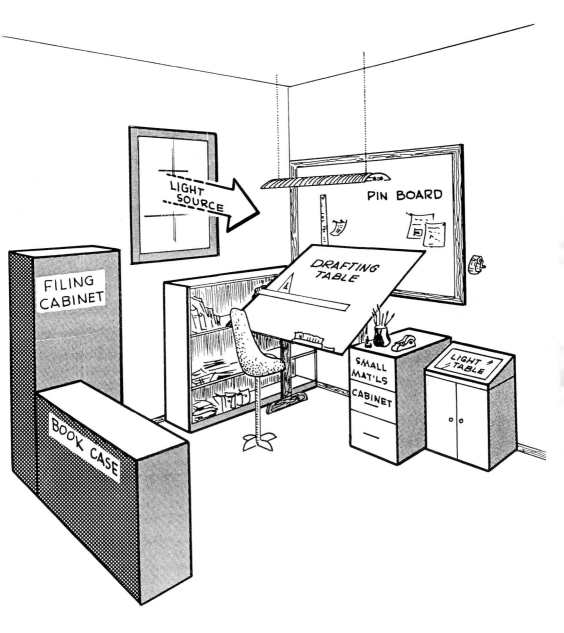

BRUSH OR PEN?

In the beginning, it is recommended that you practice each of the pen and brush exercises at least once a day at the start of your study period. As you settle on a few pens and brushes, practice the exercises with them, over and over, until you have mastered them completely. I recommend that you don't restrict yourself to too narrow a scope of pen and brush techniques. Always be open to new ideas and techniques.

The beginner may find it easier to use mechanical pens and pen sticks which, although having some practical uses, limit your expression and line character. Since they are not responsive to pressure, they tend to give a uniformity of line that can, if used exclusively, give a sterility and boredom to your work that may be undesirable. Using brushes and pens that respond to pressure, although requiring more practice in the beginning, will be well worth the effort and will reward you with real line character and added interest in your work.

Notice the difference in the results obtained with pen and brush and those obtained by pen sticks and mechanical pen.

SKETCH DONE WITH
PENS AND BRUSH.

SKETCH DONE WITH
PEN STICKS AND
MECHANICAL PEN.

SHAPING YOUR BRUSH

When inking with a red sable brush (as many cartoonists do), dip it into the ink, then shape the brush to a point by bringing it toward you on a scrap of drawing paper while twirling the handle between your thumb and index finger. This technique will keep the brush from becoming "overcharged" with ink and will give you a sharp tip.

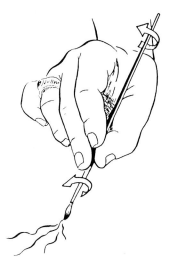

DRAWING A LINE
WITH A STRAIGHT-EDGE

The technique pictured below has been used for many years. Although it is much better than attempting a straight brush line by hand, even a heartbeat can cause a distortion unless the hand is moving rather quickly. For perfectly straight lines, I tend to use pen sticks or mechanical pens. For this purpose, they seem to work best.

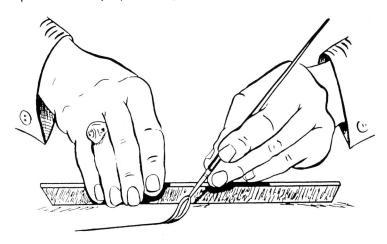

PRACTICE EXERCISES
WITH A PEN

These exercises will help you gain control and get the "feel" of your pens. They should be practiced over and over. These were done with a crow quill pen, but it is recommended that you try various types of pens. Eventually, you will choose the particular pens that work best for you.

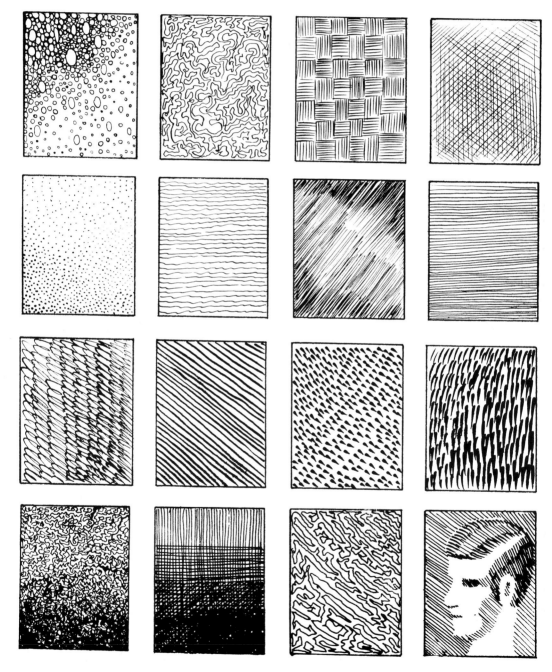

PRACTICE EXERCISES
WITH A BRUSH

The way to find the ideal brushes for you is to practice these exercises (and invent your own) using different sizes of brushes. I find a #1 long brush quite comfortable to use. Your choice should be red sable as they hold their points and are good for making curves.

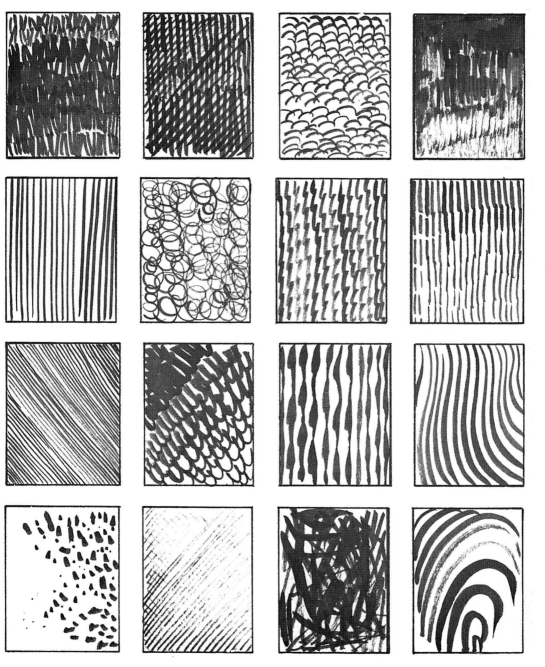

MORE PEN AND BRUSH TECHNIQUES

STIPPLE WITH DRY BRUSH

CROW QUILL
PRESSURE CONTROL

CROW QUILL "COMMAS"

INK DROPPED ONTO
WET SURFACE

CROW QUILL
PRESSURE CONTROL

WHITE OVER BLACK

Unlike most learning processes, learning to draw cartoons is a delightful experience from the very beginning. Although the serious cartoonist will want to outfit his studio with most of the supplies listed on page 4, the process of learning how to draw good cartoons can be accomplished with pencil and paper alone. The indispensable ingredient has always been, and always will be, PRACTICE! Keep in mind that each time you draw you will improve, while enjoying every step of the way. *We learn to draw by drawing!*

THE REALISTIC HEAD

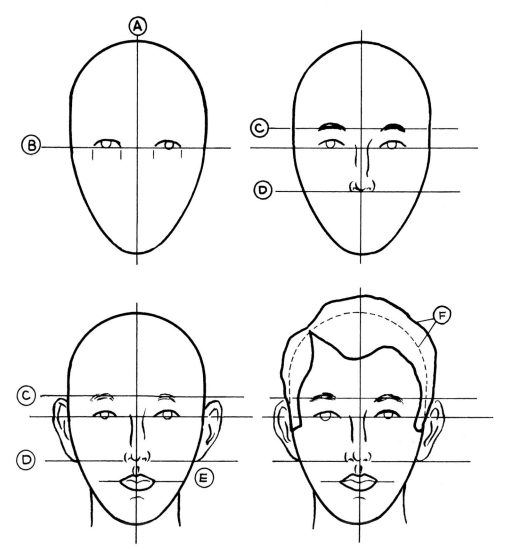

A. Divide an egg shape in half vertically.

B. Divide the shape in half horizontally and place the eyes on that line.

C. Place the eyebrows where shown.

D. Place the bottom of the nose halfway between the eyebrows and the chin.

E. Place the mouth approximately one-third way between the bottom of the nose and the chin line.

F. Draw the hair above the head, not in it.

G. Notice how the ears fall between lines C and D.

THE CARTOON HEAD

Now that we know the structure for the realistic head, let's practice developing the semi-realistic cartoon head.

Note that the more we deviate from the egg, the more cartoon-like the drawing becomes.

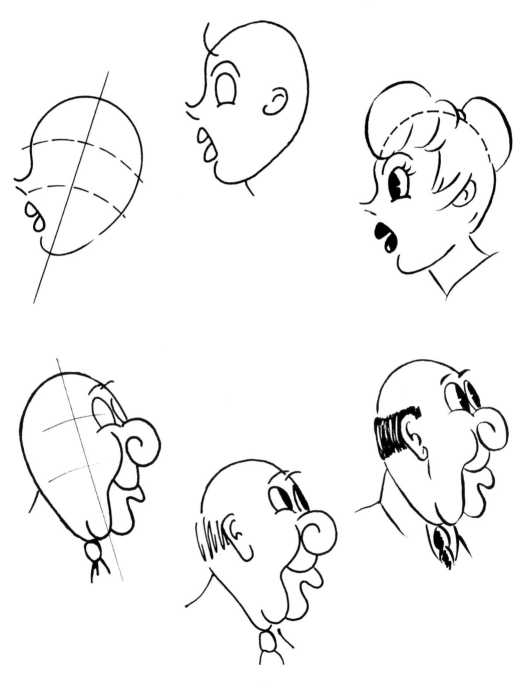

THE MOD TEEN

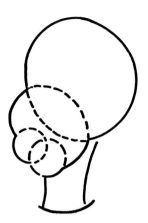

1. Using pencil, build the shape of the head with circles.

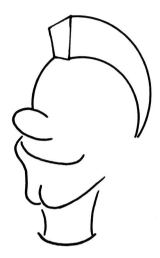

2. Refine the head, then add the nose, the hair and the mouth.

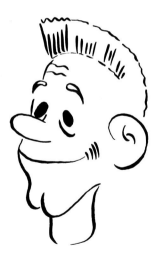

3. Add the eyes, the ears and the eyebrows.

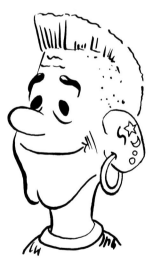

4. Add details, such as the earrings and the shirt. When your drawing is complete, ink over the pencil lines. (Inking was done with a #1 brush and a crow quill pen.)

SIMPLE
PROGRESSION

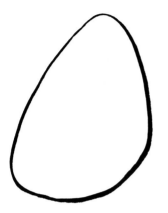

1. Decide on a shape for the head.

2. Add the nose.

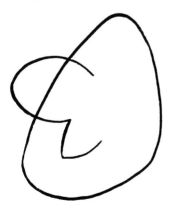

3. Add the mouth.

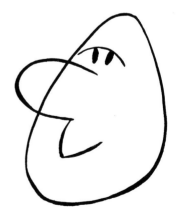

4. Add the eyes and eyebrows.

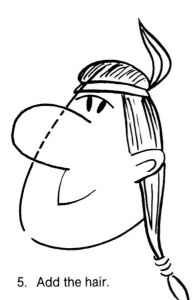

5. Add the hair.

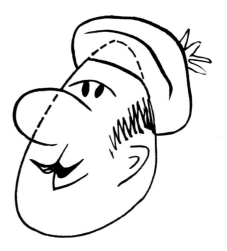

6. Or, add a hat.

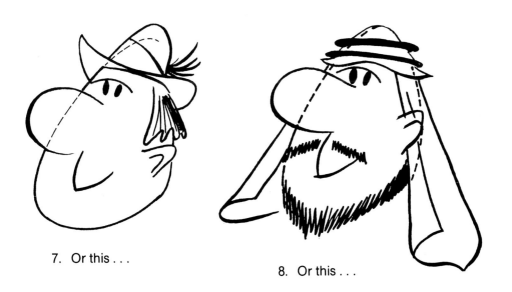

7. Or this . . .

8. Or this . . .

Notice how the same head shape and facial features can take on different personalities when you change the facial hair and hats.

THE CLOWN

This happy fellow was built of oval forms. When you draw him, think "happiness" and "flow of line."

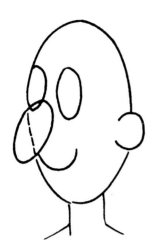

1. Using a pencil, build the shape of the head with ovals.

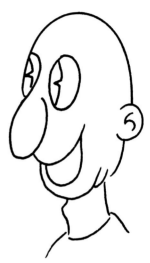

2. Refine the head, then add eye details, the mouth and the wrinkles under the chin.

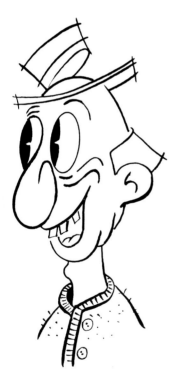

3. Add the basic shape of the hat and the hair and the teeth. Notice the reverse "S" curve flow around the eye and the nose.

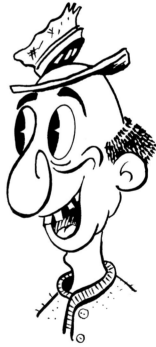

4. Now complete the hat, hair and eyebrows, then ink. (Inking was done with a #1 sable brush and crow quill pen.)

THE OFFICER

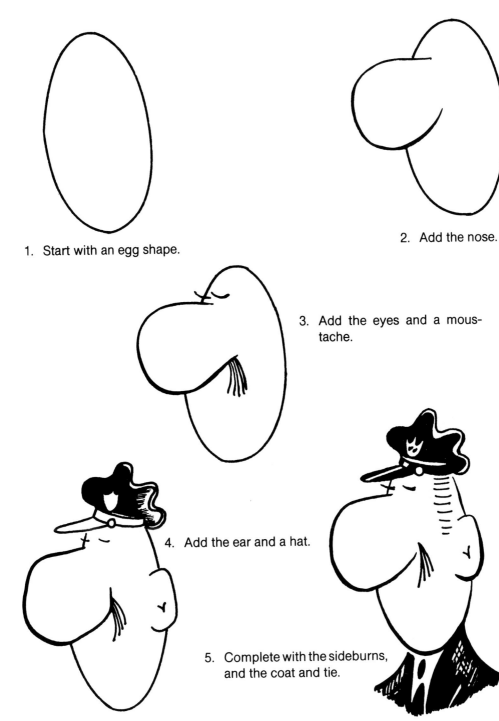

1. Start with an egg shape.

2. Add the nose.

3. Add the eyes and a moustache.

4. Add the ear and a hat.

5. Complete with the sideburns, and the coat and tie.

(The inking was done with a #1 brush and a crow quill pen.)

SIMPLICITY DOES IT

Simplicity in cartooning is as important as it is in anything else — perhaps even more so. What you leave out of a drawinig is often more important than the things you put in.

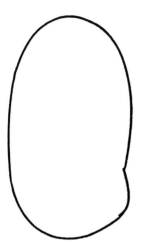

1. Draw the basic shape.

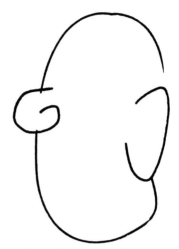

2. The placement of the nose first will help determine the attitude of the character.

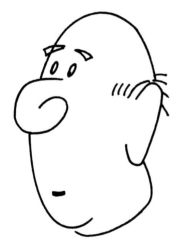

3. Note the simple eyes, mouth and eyebrows. Simplicity of line makes your drawings more inviting to the eye.

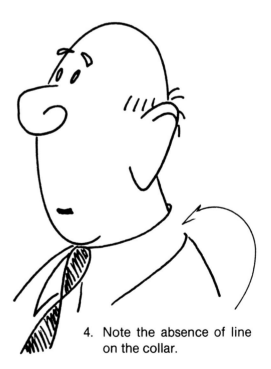

4. Note the absence of line on the collar.

THE SNOB

1. Begin with a "haughty" shape.

2. Add drooped eyelids and lifted eyebrows.

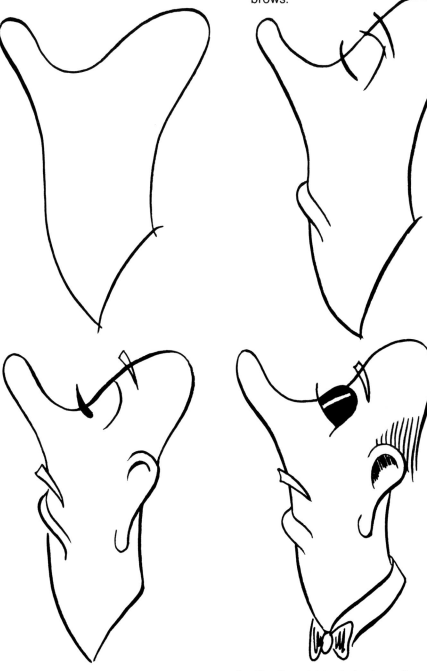

3. Add the moustache and the ear.

4. Finally, add the hair, the collar and the tie. Now you have it — "The Maitre D'!"

THE TYCOON

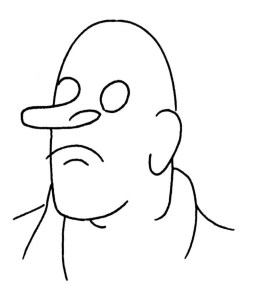

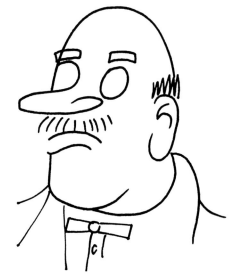

1. Draw a strong head shape with a determined nose located above the center.

2. Add strong eyebrows, the moustache and the ear. (A large lobe adds strength.)

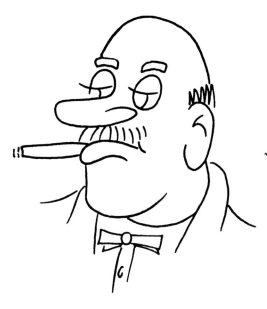

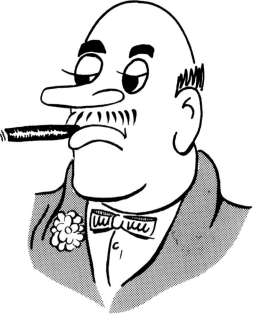

3. Add a cigar.

4. Don't allow the chin to recede even slightly, or it will weaken the character.

AGING A CHARACTER

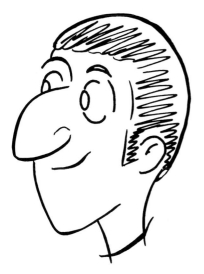

1. Here is a character around forty years old.

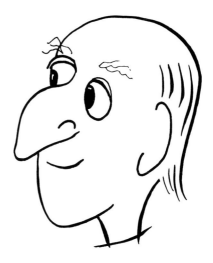

2. Thin the hair and elongate the nose and the ear. Make the eyebrows unruly and skimpy.

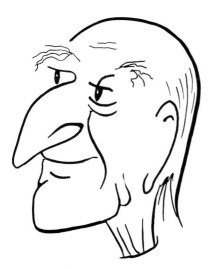

3. Make the eyes droop and draw sag lines around the mouth. Draw vertical wrinkles in the neck.

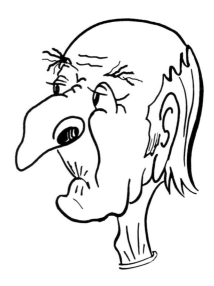

4. The loss of teeth causes the mouth to collapse and the chin to protrude.

THE TOUGH GUY

The tough guy is really a loveable character. He's easy to draw if you take him step-by-step, using the basic forms. Again, don't worry about your working lines. Draw them lightly. They will erase easily after the ink dries.

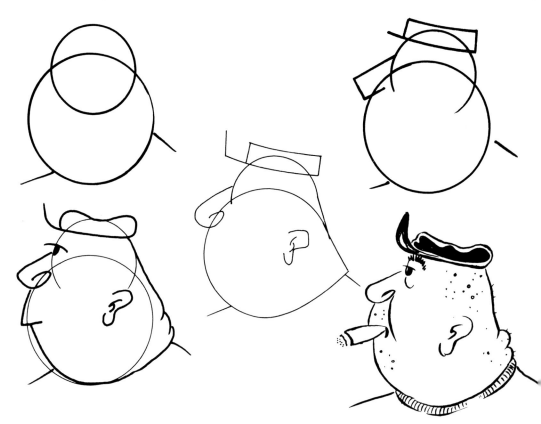

Now try changing the details and the features to create some new characters.

THE GENERAL

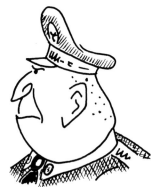

THE CHEF

THE ENGLISH GENT

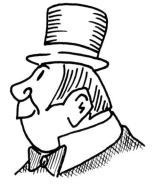

WOMAN

This little lady is quite easy and fun to draw. She could be someone's aunt, a teacher, or a librarian. She can even be changed into a grandmother by lightening her hair.

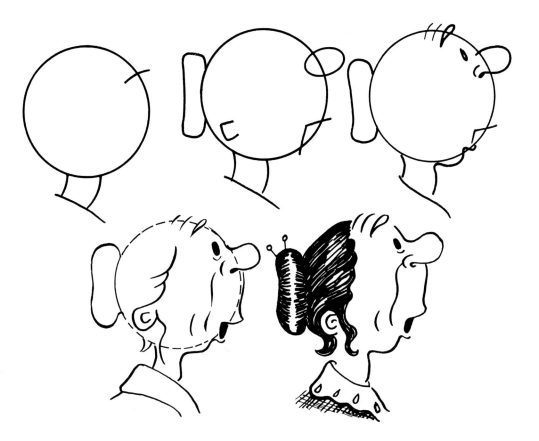

Wasn't that easy? Now, just for fun, change some of the features and details to create some new characters.

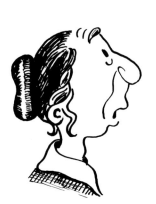

THE FLAMENCO DANCER

At times, your cartoon characters can be rather pretty. You'll have fun drawing this nice looking, but "haughty," flamenco dancer. Notice how the long neck gives her an air of elegance.

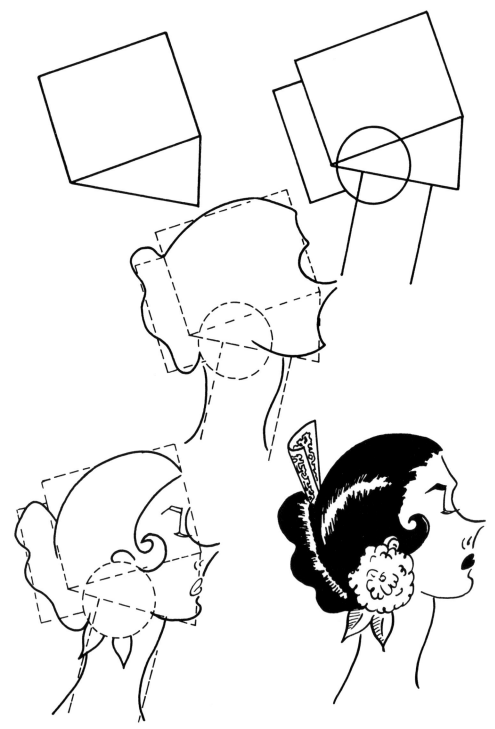

THE CHARWOMAN

Draw the charwoman step-by-step and you will be surprised at your success! Draw lightly and don't worry about your working lines.

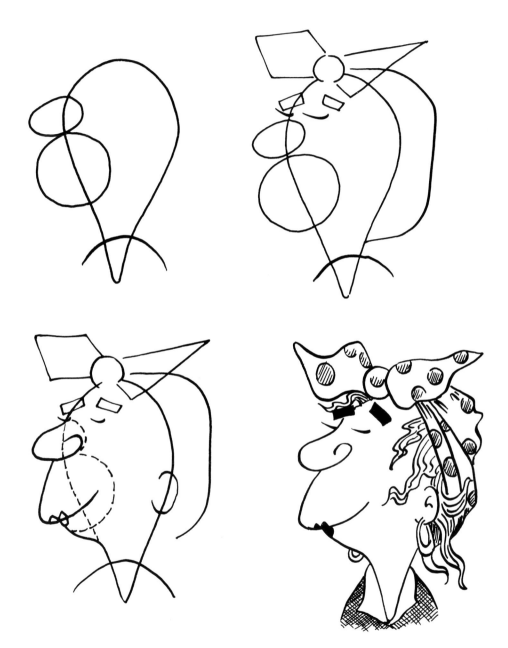

When you have drawn the face to your satisfaction, ink over the pencil lines. After the ink is dry, erase the pencil lines with a kneaded eraser. You will learn from experience that you must wait for the ink to dry completely to avoid smearing.

THE BODY

In cartoons, make the head large in proportion to the body.

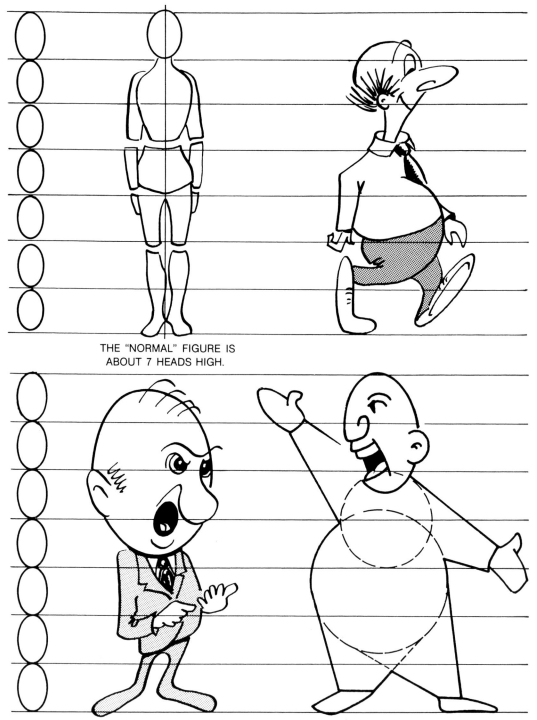

THE "NORMAL" FIGURE IS
ABOUT 7 HEADS HIGH.

Cartoon proportions rarely fit the normal figure. Although there is no set rule, the character is usually "cuter" when its head is large and the body small.

THE BODY IN ACTION

Practice drawing body shapes from your own body in front of a full-length mirror. After you have made sketches of yourself, redraw them with an emphasis on flow of line and exaggeration. Practicing in front of a mirror will help you feel the muscles used when you're in certain positions. This will be a great help in your body drawings.

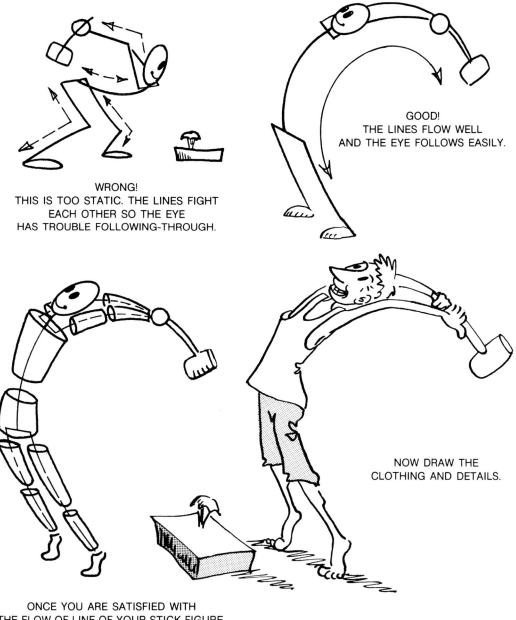

GOOD!
THE LINES FLOW WELL
AND THE EYE FOLLOWS EASILY.

WRONG!
THIS IS TOO STATIC. THE LINES FIGHT
EACH OTHER SO THE EYE
HAS TROUBLE FOLLOWING-THROUGH.

NOW DRAW THE
CLOTHING AND DETAILS.

ONCE YOU ARE SATISFIED WITH
THE FLOW OF LINE OF YOUR STICK FIGURE,
USE CYLINDERS OR OVAL FORMS
TO BUILD UP THE BODY.

BUILDING THE BODY
WITH OVAL FORMS

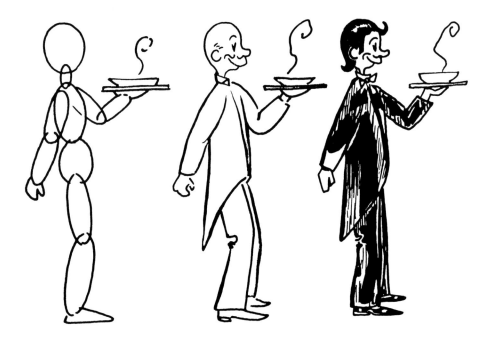

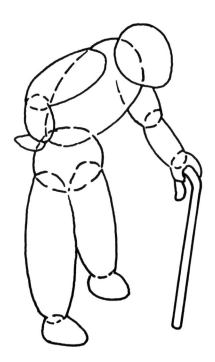

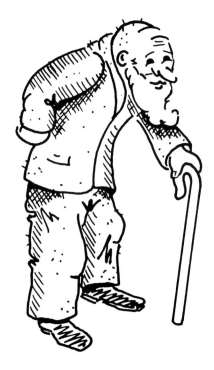

THE BODY IN PERSPECTIVE

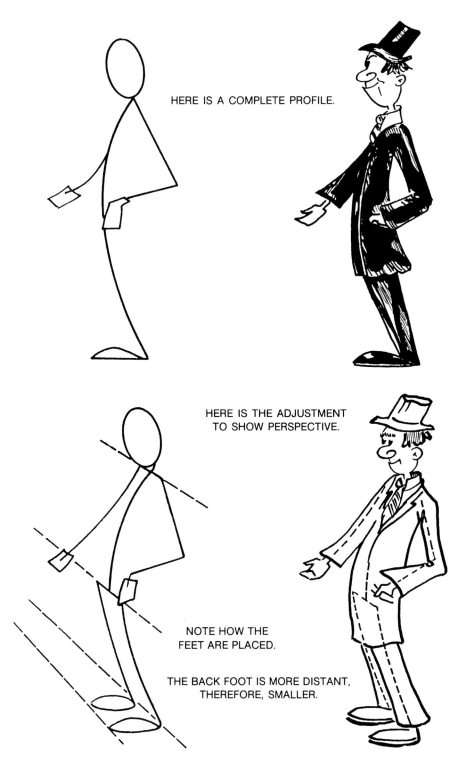

HERE IS A COMPLETE PROFILE.

HERE IS THE ADJUSTMENT
TO SHOW PERSPECTIVE.

NOTE HOW THE
FEET ARE PLACED.

THE BACK FOOT IS MORE DISTANT,
THEREFORE, SMALLER.

THE BODY IN CARTOON MOVEMENT

The quality of your figure's design can be double-checked by considering its silhouette. A good silhouette can help the less observant viewer "zero in" on the movement.

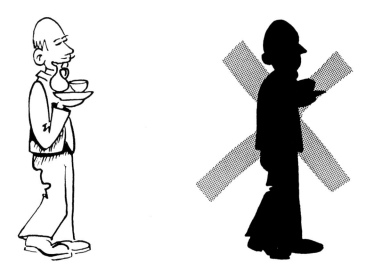

BAD! THIS HAS TO BE STUDIED TO DETERMINE THE ACTION.

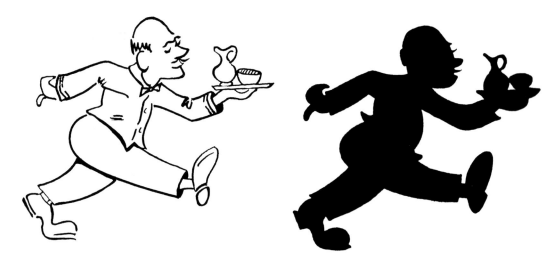

GOOD! HERE THE ACTION "JUMPS" OUT AT THE VIEWER. MAKING LESS WORK FOR THE EYE IS INDICATIVE OF GOOD CARTOONING.

Strive for a good silhouette!

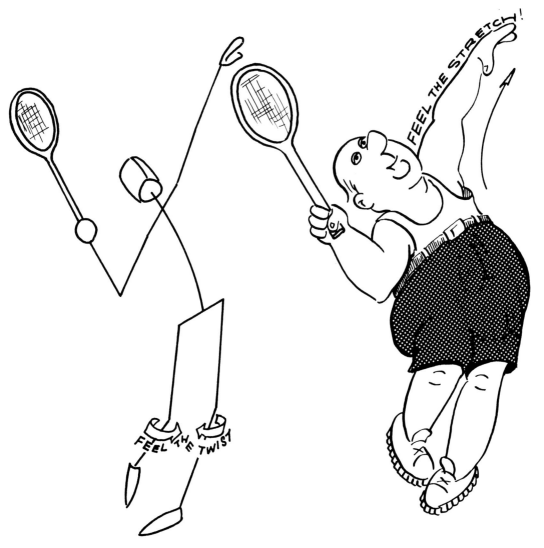

Just because you start with a stick figure, it doesn't follow that all your characters must be skinny. See how this "portly" character has been built up from the stick figure.

For excellent references of exaggerated body lines, consult the sports page of your newspaper.

THE CARTOON WALK

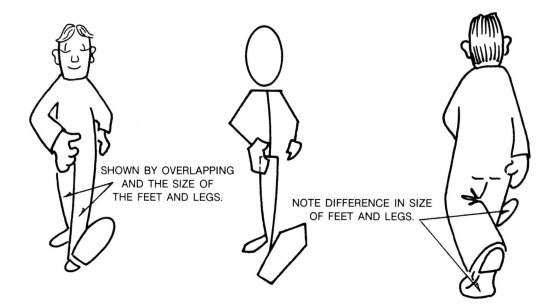

SHOWN BY OVERLAPPING
AND THE SIZE OF
THE FEET AND LEGS.

NOTE DIFFERENCE IN SIZE
OF FEET AND LEGS.

Moving Forward and Away

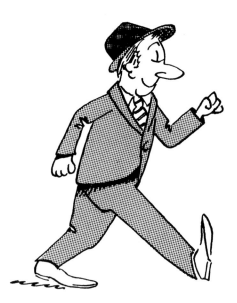 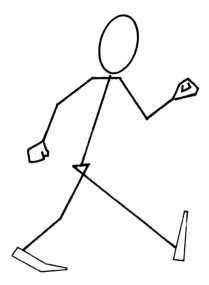

THE CARTOON RUN

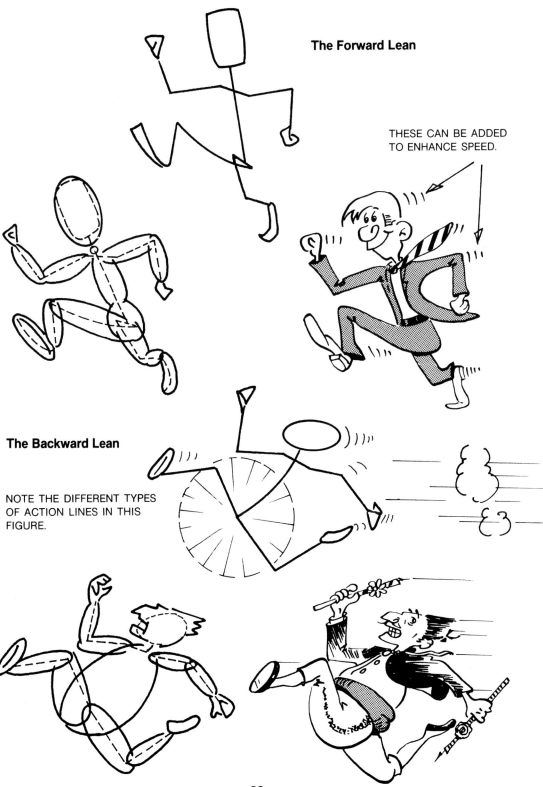

The Forward Lean

THESE CAN BE ADDED TO ENHANCE SPEED.

The Backward Lean

NOTE THE DIFFERENT TYPES OF ACTION LINES IN THIS FIGURE.

EXAGGERATING
THE HUMAN FORM

NORMAL FIGURE EXAGGERATIONS

EXAGGERATIONS

FEET AND FOOTWEAR

Feet are easier than hands to suggest, but they sometimes get awkward if we don't know a few basic rules.

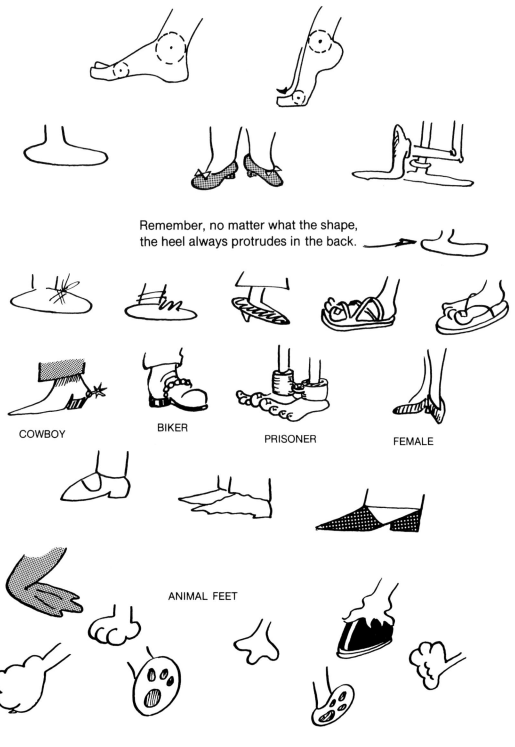

Remember, no matter what the shape, the heel always protrudes in the back.

COWBOY

BIKER

PRISONER

FEMALE

ANIMAL FEET

HANDS

The hand can be broken down into basic forms. The palm is a nearly square wedge. The finger wedge is just about the same length as the palm.

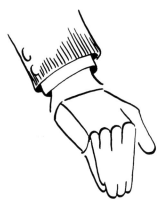

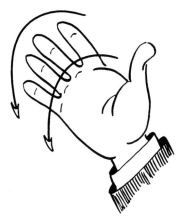

THE FINGERS FORM A CURVE —
NOT A STRAIGHT LINE!

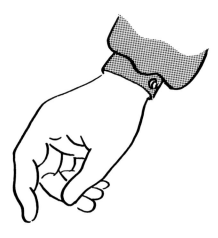

Practice drawing the hand in many different positions. Once you have mastered the realistic hand, the cartoon hand is easy.

MORE HANDS

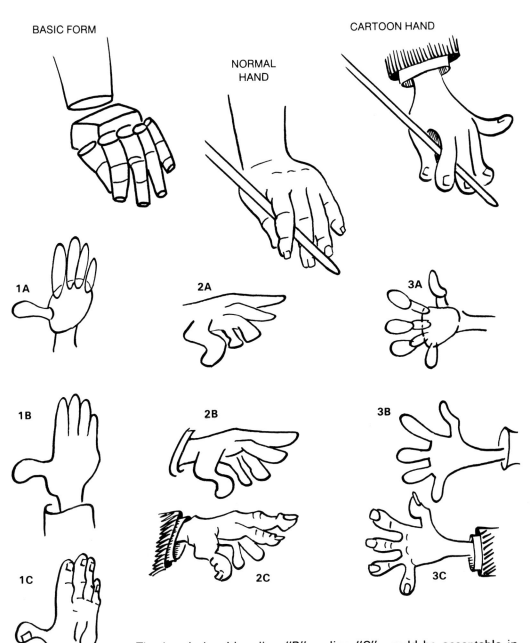

BASIC FORM

NORMAL HAND

CARTOON HAND

1A 2A 3A

1B 2B 3B

1C 2C 3C

The hands in either line "B" or line "C" would be acceptable in cartoons; "C" being more detailed than "B." Decide to which degree you wish to take your drawing, and then STOP! Knowing when to stop is a technique which must be developed.

CHILDREN

All features of the child's head are located below the halfway mark.

The cheeks are chubby and full, the chin is small, the eyebrows are very light, and the neck is short.

Now that you understand the placement of the child's features, apply this to the faces of your cartoon kids.

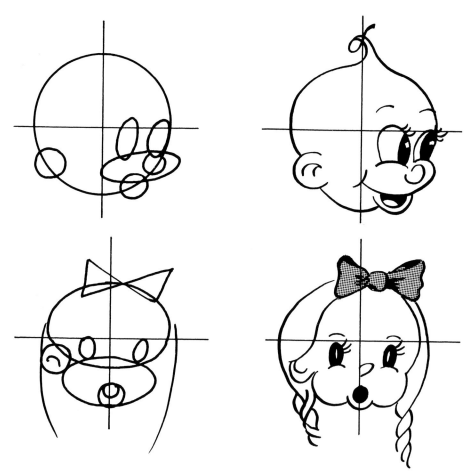

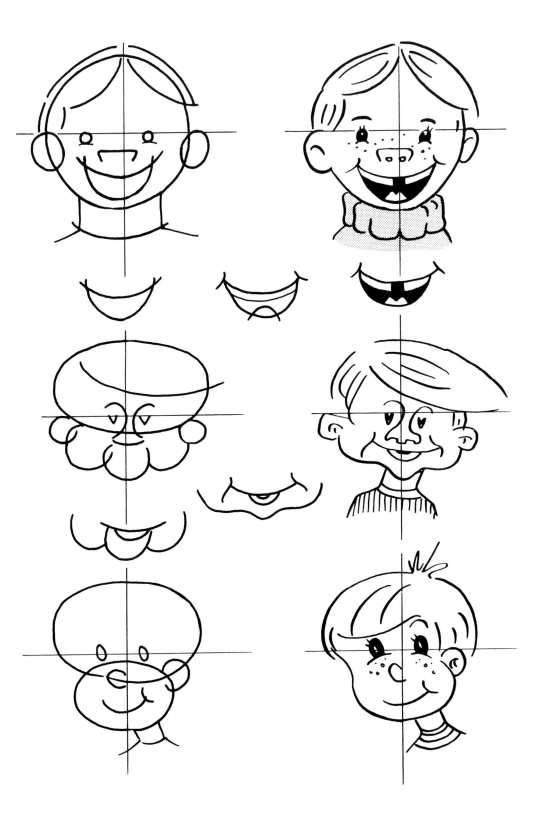

CHILDREN'S EYES

When drawing children's eyes, be sure to consider the placement of the eyebrows. Don't draw them too close to the eyes. Lifting them a bit gives your child a look of wild-eyed innocence typical of young children.

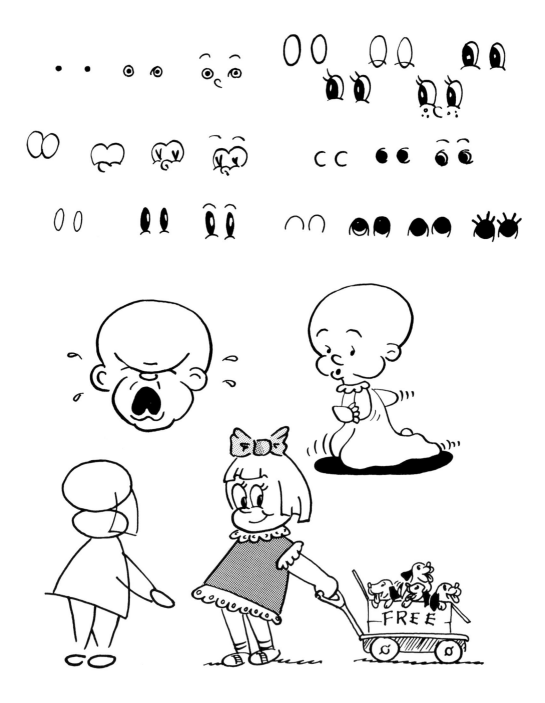

ANIMAL HEADS

Notice how easy it is to draw two entirely different animals from the same basic form.

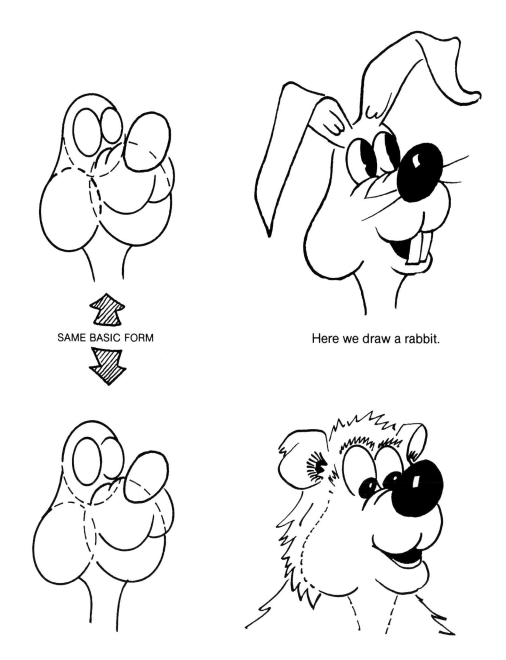

SAME BASIC FORM

Here we draw a rabbit.

By widening the head and neck, then changing the shape of the teeth and ears, we have a friendly bear. It is easy to make other animals based on this same basic form. Try it! And remember, each time you try, you get better!

DEVELOPMENT OF BASIC FORM
INTO DESIRED HEAD SHAPE

①

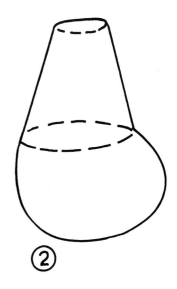

②

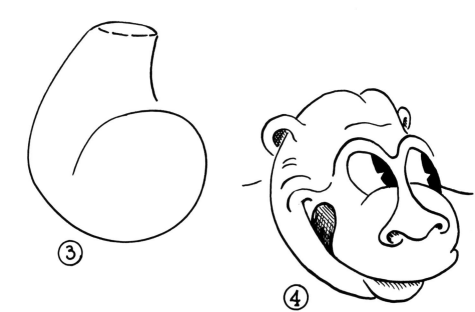

③

④

PEPPY

When drawing animals, it is fine to use photographs for reference. When possible, sketch from animals you can see (at the zoo or a farm), or from animals you know. This is a drawing of Peppy Cola (Cola means "tail" in Spanish). Peppy has lived with me for eighteen years now and is still "peppy." The exaggerations I have made have helped capture her personality.

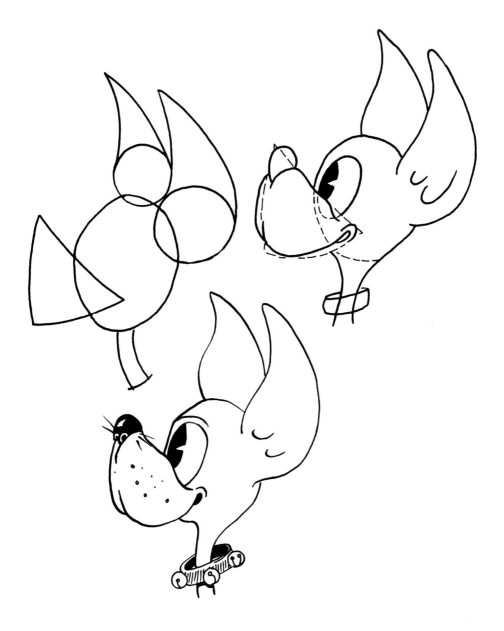

BRINGING ORDINARY OBJECTS TO LIFE

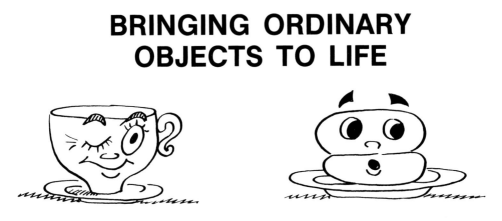

If you plan to use your cartooning talent to supplement your income, sooner or later you will be called upon to animate inanimate objects. Look around the room at the many objects around you. See how many you can bring to life — the telephone, a lamp, a water cooler, a wastebasket . . . They are all waiting for you to give them "life."

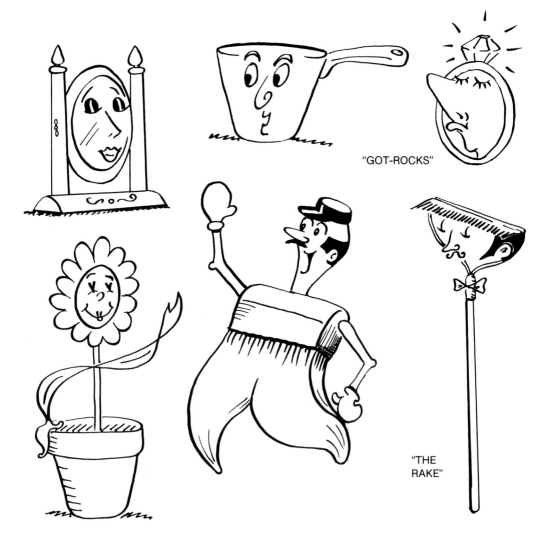

"GOT-ROCKS"

"THE RAKE"

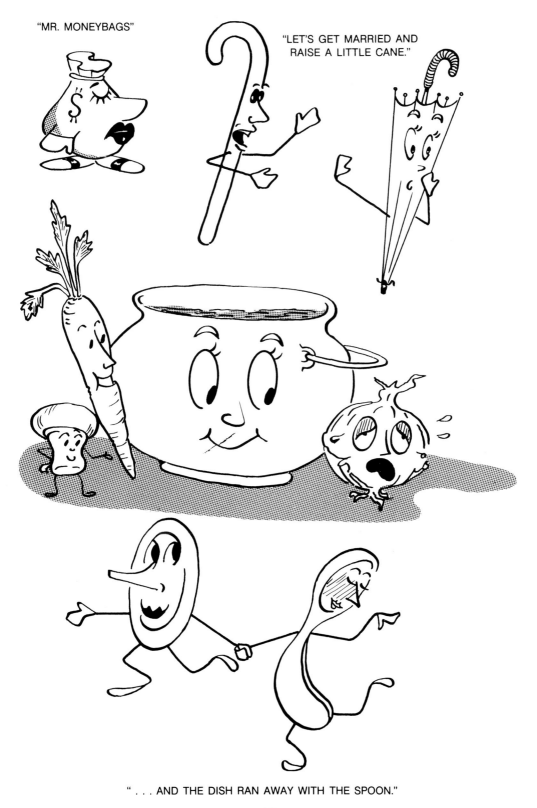

45

CLOTHING AND FOLDS

Think of folds as falling in straight lines instead of curves. This will simplify drawing the basic form of drapes or clothing, thus, making the finished product more believable.

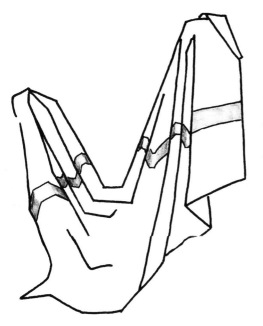

An excellent exercise is to place a piece of fabric (preferably with some lines in the design) in a drapery "still life." Remember, draw the folds in straight lines; this will separate the planes.

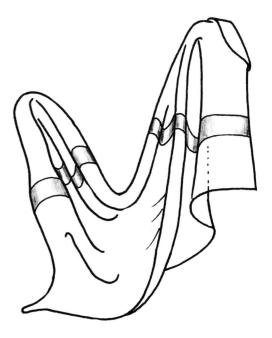

... Next, redraw using the curves you see on the fabric. Develop a feeling for the peaks and the valleys of the folds. After a couple of times practicing this technique, you will be surprised how easy it becomes!

Notice the breakdown of the planes in the folds below.

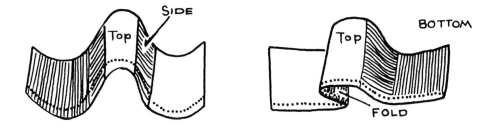

Once these principles are understood, you can then proceed to use folds at the stress points of your cartoons. Study the folds in your friends' clothing. Notice how folds fall (or don't fall) in extreme case, such as with rotund or thin people. Don't overdo, and remember, it is better to leave it out than to put it in wrong.

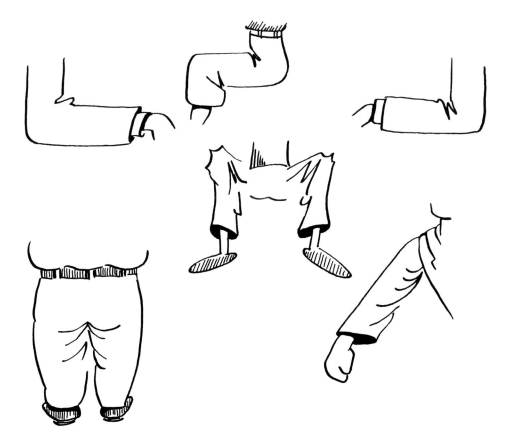

LETTERING

Everyone agrees that a cartoon is only as good as its lettering. Here we will deal with basic lettering — nothing fancy — but, if you can master this simple technique, you will add much to your cartooning. Simple, clean, sharp lettering makes reading your cartoon enjoyable.

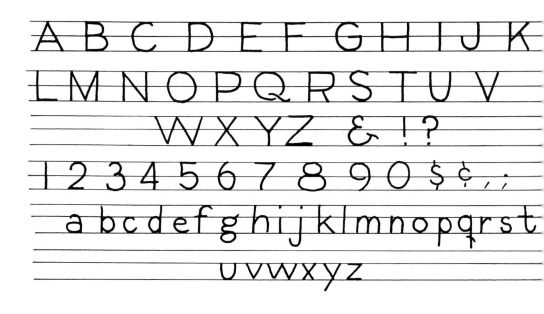

Establish the height of your letters by drawing light guidelines with a T-square. A favorable impression will be left upon your viewers if you select a style, whether upper- or lowercase, and stick with it. Don't be guilty of the following:

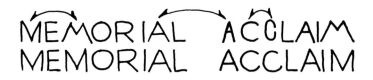

Notice that the inconsistencies of the M's, A's and C's in the first line above are less pleasing to the eye.

A common fault occurs when the artist is executing one letter, and thinking about the letter to follow. This causes a subconscious hurrying that results in poor workmanship. Concentrate on each individual letter. Develop the attitude that you will work on each letter until it is just right, even if it takes you all day. You will find that it won't take all day. As a matter of fact, it will hardly slow you down at all. You will, however, end up with an improved finished product.

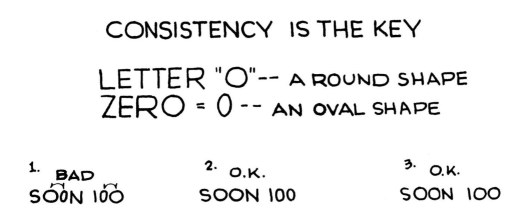

CONSISTENCY IS THE KEY

LETTER "O" -- A ROUND SHAPE
ZERO = 0 -- AN OVAL SHAPE

1. BAD
SOON 100

2. O.K.
SOON 100

3. O.K.
SOON 100

It is okay to use the round form for both the letter and the number, but be consistent; avoid the inconsistencies of #1 above.

This preoccupation with shapes should extend to the spacing of letters. They should proceed across the allotted space in an optically pleasing manner. When properly drawn and spaced, your lettering is said to have "good color."

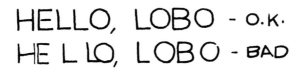

HELLO, LOBO - O.K.
HE L LO, LOBO - BAD

Unless you are one of those "naturals" who were born lettering well, you will need to practice a little each day — the rewards are well worth the effort.

AT TIMES YOU MAY WANT TO EMPHASIZE A WORD BY MAKING IT LARGER OR **BOLDER.**

ALSO YOU MAY FIND IT EXPRESSIVE TO DRAW THE WORD IN SUCH A MANNER AS TO REFLECT ITS MEANING.

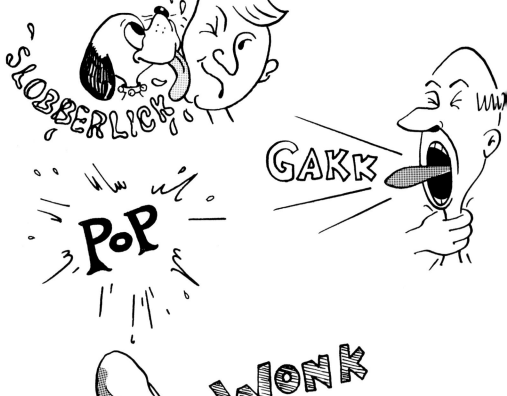

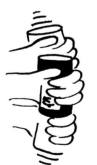

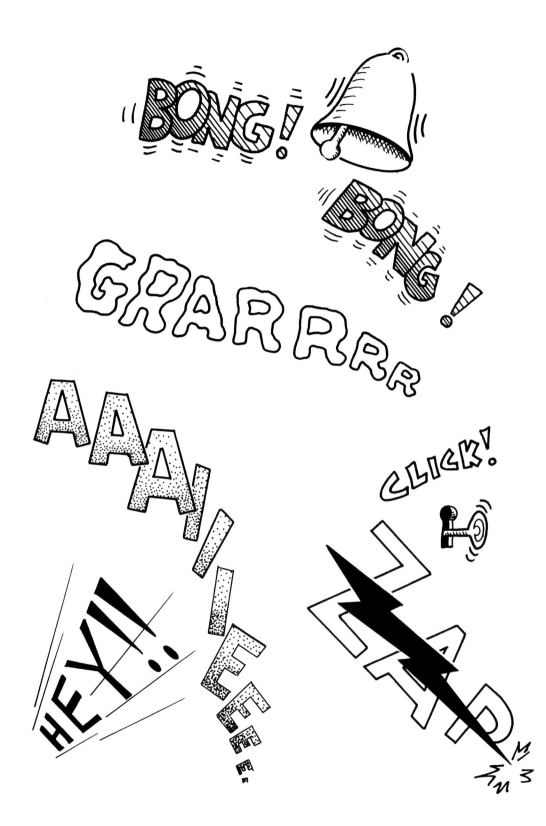

BALLOONS

Balloons are the "voices" of cartoons. It won't take you long to decide which balloons work for you. Below are some treatments you may wish to consider for your cartoon voices and thoughts.

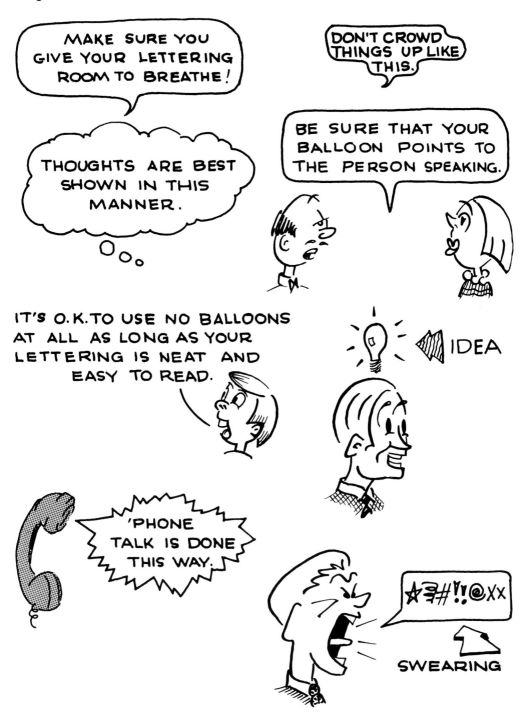

MAKE SURE YOU GIVE YOUR LETTERING ROOM TO BREATHE!

DON'T CROWD THINGS UP LIKE THIS.

THOUGHTS ARE BEST SHOWN IN THIS MANNER.

BE SURE THAT YOUR BALLOON POINTS TO THE PERSON SPEAKING.

IT'S O.K. TO USE NO BALLOONS AT ALL AS LONG AS YOUR LETTERING IS NEAT AND EASY TO READ.

IDEA

'PHONE TALK IS DONE THIS WAY.

SWEARING

THE ANIMATED WALK

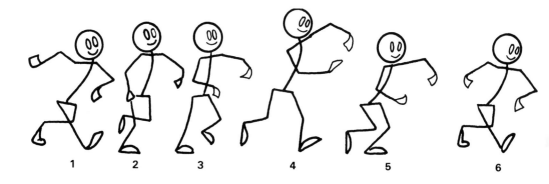

1 2 3 4 5 6

Try a simple animated walk sequence. First, draw the stick figure in motion. Figure 1 is leading with the right foot thrust forward. Figure 2 places the right down and has lifted the left foot. Figure 3 has lifted the left foot and brought it forward. Figure 4 is just about to place the left foot down. Figure 5 has planted the left foot firmly down and is lifting the right foot in preparation to swing it forward again. Notice that Figure 6 is back at the same position as Figure 1. This completes the cycle, which may be repeated by following with Figure 2 and so on.

Having worked out the cycle first in stick figures, we are now ready to add detail to our character.

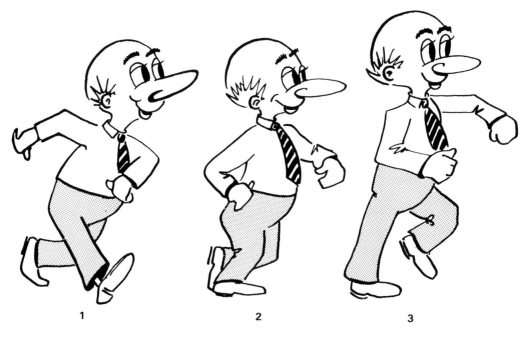

1 2 3

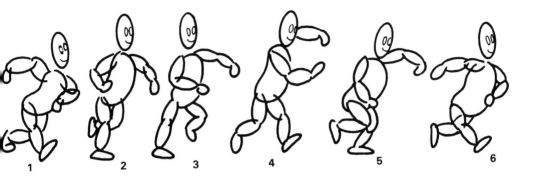

You may find it easier to fill out your stick figure with oval forms before adding the details.

Notice that the liveliness of the walk and the smiling face work together to produce a happy character that is pleasant to the viewer.

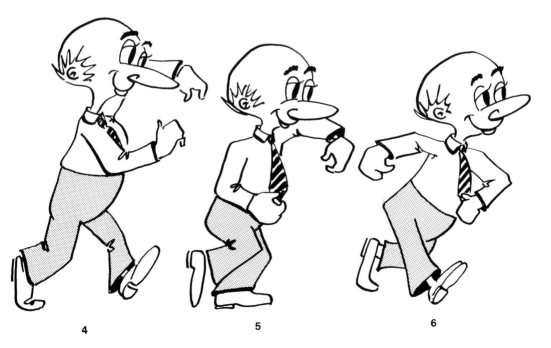

WASH DRAWING

Wash drawing is a black and white treatment of your cartoon that ranges from black, through shades of gray, to white. A wash gives "body" to the cartoon. You only have ten to fifteen seconds to "hook" the viewer into reading your cartoon. The contrast afforded by the wash serves as the needed attention-getter.

Wash drawing is done by mixing either black watercolor pigment or india ink with water. Brushes can vary depending on the detail desired. In addition to a wash brush (#8 sable), it is good to have a #3, #4 or #6 red sable and a couple of flat sables with good chiseled edges on hand. Because of the wetness desired, you should use a thick watercolor paper or a good illustration board. This will prevent undue warping.

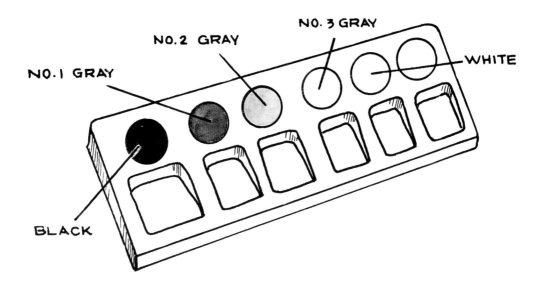

Shades of gray should be mixed ahead of time in a watercolor tray with cup-like depressions. This makes your wash easier and more controllable. It is best to limit yourself to black and white and no more than three grays — at least in the beginning.

Let's begin by wash drawing a simple figure. First, lightly draw the figure with a pencil. You should just barely be able to see your work, it will be dark enough and will clean up easily later.

Create your cartoon on typing paper or tracing paper. After it is drawn to your satisfaction, transfer the drawing to your finished paper or illustration board.

TRANSFER YOUR DRAWING BY . . .

TRANSFER SHEET

If you are using an illustration board for your finished drawing, it will be necessary to use a transfer sheet, which is similar to carbon paper. Graphite transfer paper is available in 8½" x 12" sheets and in rolls, 12" x 12'. (If you are unable to obtain a commercial paper, see "Making And Using Transfer Paper," page 60).

LIGHT TABLE

If you are using drawing paper for your finished drawing, you can transfer your work using a light table. A good one can be purchased at an art supply store for about $80.00. I made mine much cheaper (see "Light Table Construction," page 61).

After transferring the drawing, you are now ready to ink it with waterproof india ink (any other kind will run when you wash over it.) When the ink is completely dry, clean your drawing with a "kneaded eraser" (available at art supply stores). Do your drawing with clean hands; the oil, even from touching your forehead, will leave a blotch when you wash over a fingerprint.

Now you are ready for the wash.

1. Prepare your grays in watercolor cups as shown on page 56.

2. Get out the brushes you will use (you won't have time to look for them once you get started). For page 59, I used a flat sable, a #4 for the large areas, and a #3 sable for the tight areas (i.e., the fingers and around the whites of the eyes). In this case, I used a long-hair liner brush to ink the sweeping lines of the drawing.

3. Attach your dried ink drawing to a board and tilt it so the wash will creep down and not puddle. If you have a drafting table, all the better. Since it's best to flow from black to white, and I chose to have this cartoon darkest at the bottom, I worked with the drawing upside down.

4. Next, wet the area you are going to wash first with clear water. Take care not to brush outside the areas you intend to wash; remember, the wash goes wherever there is water. You can tilt your drawing toward the light and the wet areas will show up. After the drawing has dried for about one minute, go over it again with clear water. This will give you an even wetness. If the water puddles up at the bottom, remove the excess with a dry brush. Now paint in your black up by the feet, then the second color (#1 gray), then on down until you bleed out to a white face.

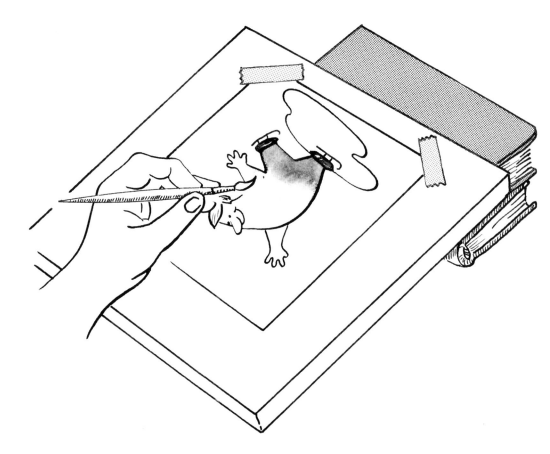

5. After you have washed the ice area and your drawing is completely dry, add a few vertical lines with india ink and with opaque white.

Don't be discouraged if the first few attempts do not turn out as well as you had hoped. This is a technique that, with practice, will greatly enhance your cartoons.

MAKING AND USING TRANSFER PAPER

Cover one side of a sheet of tracing paper or vellum with a 4B or 6B pencil. Obtain a smooth, even graphite surface by rubbing lightly with a tissue moistened with rubber cement thinner. The transfer paper can be used over and over.

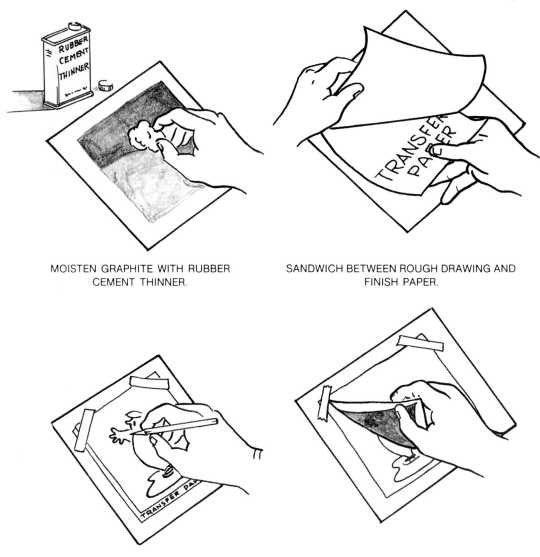

MOISTEN GRAPHITE WITH RUBBER CEMENT THINNER.

SANDWICH BETWEEN ROUGH DRAWING AND FINISH PAPER.

TRACE DRAWING.

CHECK DRAWING AFTER TRACING A FEW LINES.

Sandwich the tracing (graphite side down) between your finish paper (or board) and your rough drawing. Trace the drawing. Be sure to check after drawing a few lines to make sure your image is being transferred properly — too much pressure will indent the board, lessening the control of your inking; too little pressure will not give you a good image.

LIGHT TABLE CONSTRUCTION

A simple light table can be constructed as follows:

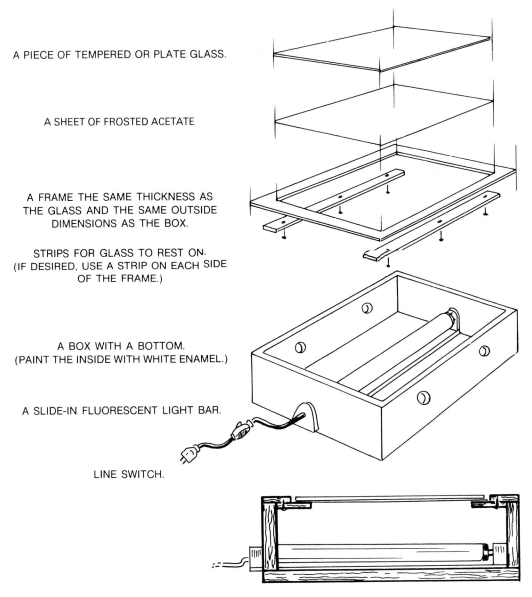

A PIECE OF TEMPERED OR PLATE GLASS.

A SHEET OF FROSTED ACETATE

A FRAME THE SAME THICKNESS AS
THE GLASS AND THE SAME OUTSIDE
DIMENSIONS AS THE BOX.

STRIPS FOR GLASS TO REST ON.
(IF DESIRED, USE A STRIP ON EACH SIDE
OF THE FRAME.)

A BOX WITH A BOTTOM.
(PAINT THE INSIDE WITH WHITE ENAMEL.)

A SLIDE-IN FLUORESCENT LIGHT BAR.

LINE SWITCH.

FINISHED LIGHT TABLE.

When I built my light box, I let the measurements be dictated by the size of a piece of tempered glass I had removed from the front of an old television. Check with your local T.V. repair shop for junk sets. If you can't find one, a piece of plate glass or plexiglas can be used. (I prefer plate glass as plexiglas has a tendency to bend.)

SPLATTER-TEXTURE TECHNIQUE

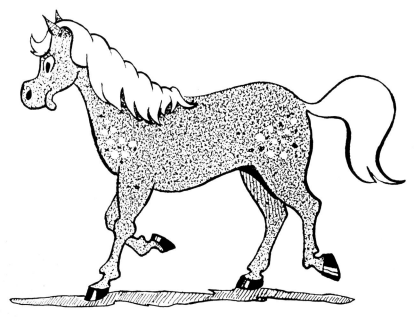

This is an effective, though relatively simple, technique for giving your drawing a professional look. First, mask off the shape not to be shaded with a stencil or frisket paper. Then, dip a toothbrush in india ink and draw a knife blade over it, moving your hand from side to side as you spray. After the splattered area dries, remove the stencil or frisket paper and add large white and black spots with a pointed brush. I usually use a "splatter box" (any cardboard box with one side removed) to protect the surrounding area.

CREATIVITY

All of us, especially as children, have seen forms in clouds . . . Mickey Mouse's head . . . a horse . . . a face Sometimes these forms jump right out at you. A good exercise in creativity is to concentrate on seeing these forms. Don't be afraid of being silly. One morning I looked out my window and saw Don Quixote peering over the roof at me. Try seeing faces and forms in other parts of nature also.

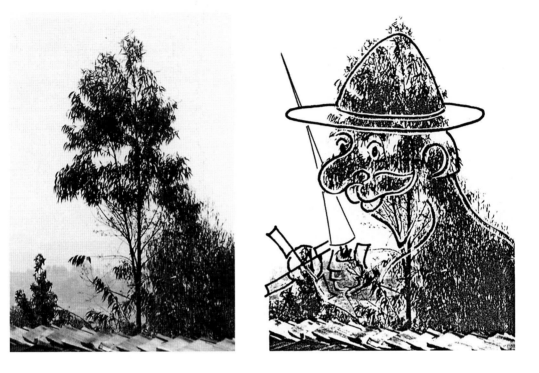

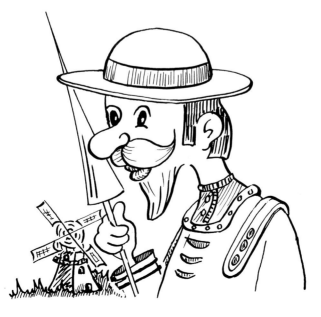

DEVELOPING IDEAS

Always carry paper and pencil for ideas as well as for sketches. For some reason I always get my best ideas between 4:00 a.m. and 6:00 a.m. For this reason, I keep a pencil and pad on my nightstand. Record ideas immediately or you will forget. Honest — you will!

Often your friends will supply you with good material without being aware of it. A friend of mine taxied his plane to the hangar after a short flight. After pulling to a stop he heard a loud CRASH! The motor had actually fallen out of the plane onto the ground. On his birthday, a few days later, I gave him the following cartoon.

This type of cartoon is funny only to those involved in the story. Don't try to sell a cartoon like this to the general public. Since they don't know the details, they won't see the humor in it.

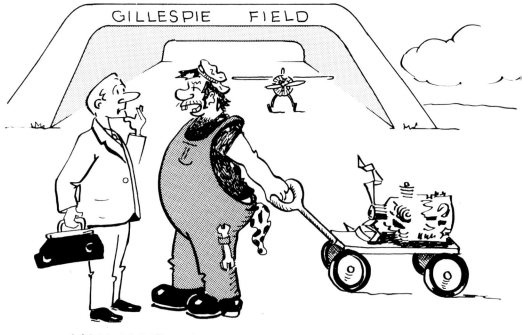

YOU WEREN'T KIDDING WHEN YOU SAID YOUR MOTOR WAS MISSING, DOC. I FOUND IT IN BOSTONIA!

Remember, if a situation causes laughter at no one's expense, it will probably make a good cartoon.